I, John Ringling, a resident of Sarasota, in the State of Florida, do hereby make, publish and declare this my last Will and Testament....To the State of Florida, I give, devise and bequeath my art museum and residence at Sarasota, Florida, now respectively known as 'The John and Mable Ringling Museum of Art' and 'Cad D'a' Zan'(sic) together with all paintings, pictures, works of art, tapestries, antiques, sculptures, library of art books, which may be contained in said museum and/or residence or which may properly belong thereto...said museum shall always be known as 'The John and Mable Ringling Museum of Art' without power in anyone to change such name...."

Last Will and Testament of John Ringling

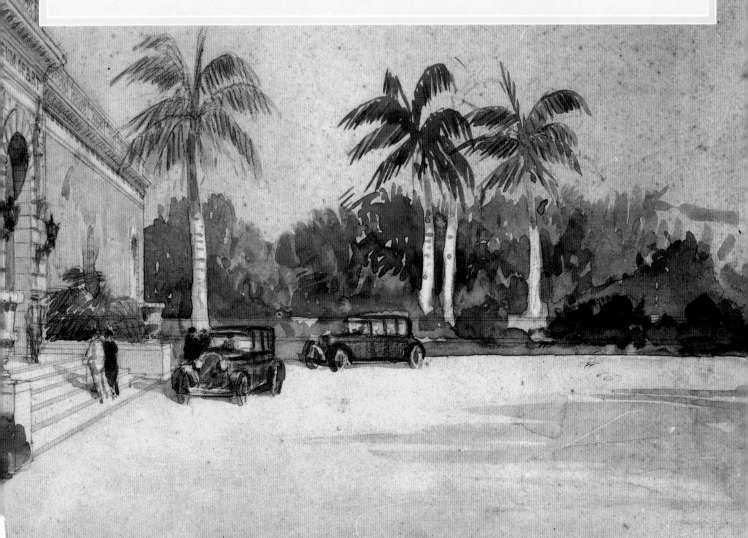

NGLING MUSEUM OF ART·SARASOTA FLA.

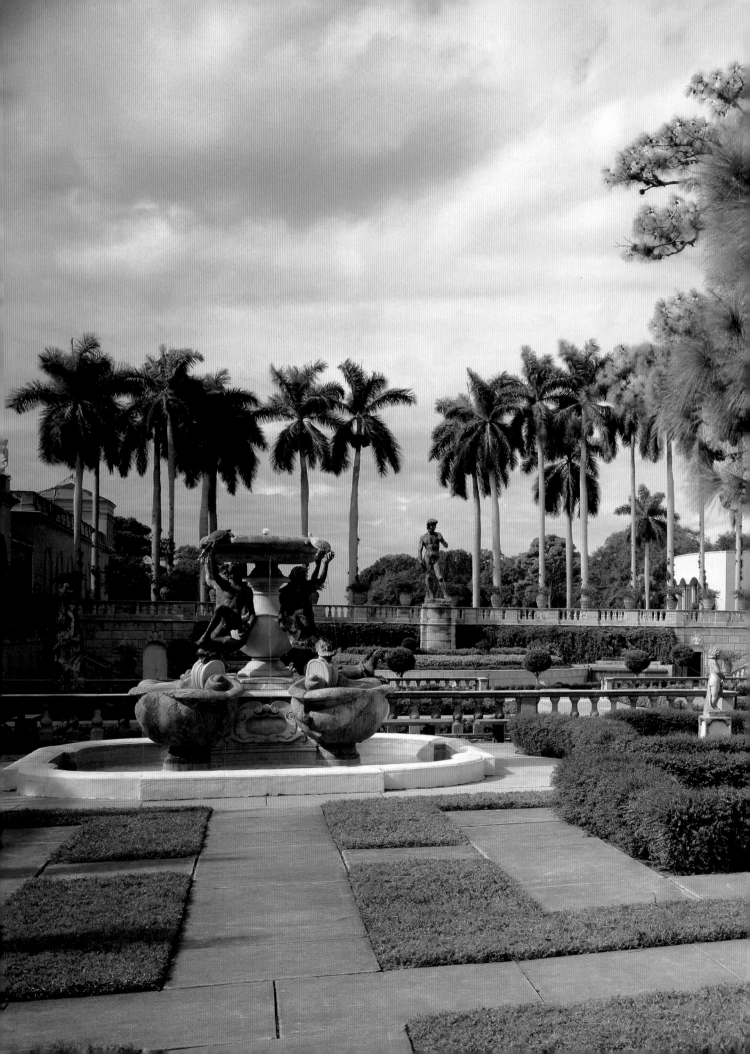

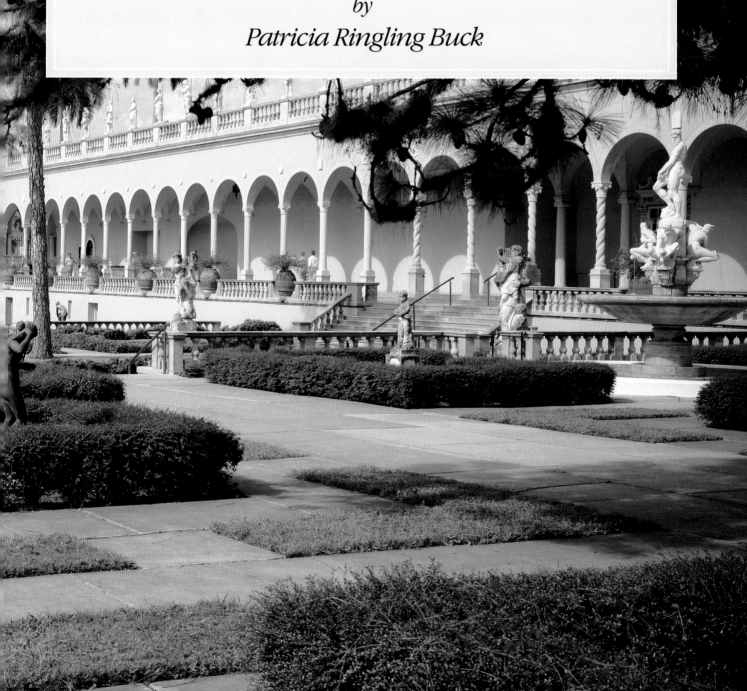

The John and Mable Ringling

Museum of Art

by

Patricia Ringling Buck

The John and Mable Ringling
Museum of Art
5401 Bayshore Rd.
Sarasota, Florida 34243
(813) 355-5101

The state art museum of Florida

Produced by Sequoia Communications,
2020 Alameda Padre Serra, Santa Barbara, CA 93103

Design by Scott F. Reid and Associates
Edited by Nicky Leach

Additional photography by C. Harrison Conroy and Florida State Archives. Map on p. 48 Copyright 1988, National Geographic Society. Reprinted with permission from the Spring 1988 issue of National Geographic *Traveler.*

Printed in Hong Kong
ISBN: 0-917859-33-2

Director's Preface

This book was born of the necessity to introduce the Museum visitor and general reader to the fine collections, fascinating architecture, and intriguing creator of one of America's major cultural institutions.

Created in the 1920s, The John and Mable Ringling Museum of Art, despite six decades of growth and development, vibrantly reflects the themes and preoccupations of the period and its founder. This reflected image is evident in the extent and opulence of its art collections, and the eclectic and often whimsical character of its European, especially Italian, inspiration.

Since the name Ringling is so closely identified with the American circus, it too often comes as a surprise to the general public that John Ringling was as much a general businessman and financier as any of the great millionaire businessmen of the period. Most importantly, like Henry Frick, Andrew Carnegie, J. P. Morgan, and other business giants of the 19th and early 20th centuries, Ringling aspired to be and, given the evidence of his Museum, became one of the "culture barons" of American history.

Collecting primarily, though by no means exclusively, in the area of Italian and Flemish art of the 17th century, and setting his extensive collection of Old Masters in an Italianate palace, was one of John Ringling's primary preoccupations.

When he died, Ringling left his cultural accomplishments to the people of Florida in the form of a major art collection, his "Italian Villa" museum, a Venetian-inspired palace on Sarasota Bay, and extensive gardens. Today, his achievement as a collector and museum-builder rivals that of the more commonly appreciated business magnates of American history, and provides the people not only of Florida but of the nation with a splendid and important museum for the public.

At this writing, the state of Florida has undertaken a comprehensive restoration of the Museum, which by 1991 will ensure the physical and historical integrity of the Museum's buildings and galleries and bring a modern infrastructure to John Ringling's achievement.

The cultural legacy of John Ringling is for you and everyone to enjoy.

Laurence J. Ruggiero
Director

Acknowledgements

It is appropriate to acknowledge and thank the members of the Board of Trustees of The John and Mable Ringling Museum of Art and the Board of Directors of the Museum Foundation for their support of the project that made the publication of this book possible.

I am indebted to many members of the staff of The John and Mable Ringling Museum of Art for their assistance, particularly P.J. Sproat, who managed the project; Lynell Morr, Librarian, and her assistant Wilma Kistler; Pam Palmer, Registrar; Howard Agriesti, Photographer; and Public Affairs Officer Robert Ardren. My special thanks to Museum Editor Kathleen Chilson, and most of all, to Dr. Laurence J. Ruggiero, Director and Chief Curator, whose formidable resolve is ensuring the restoration and preservation of John Ringling's legacy.

Patricia Ringling Buck
Communications Officer
The John and Mable Ringling Museum of Art

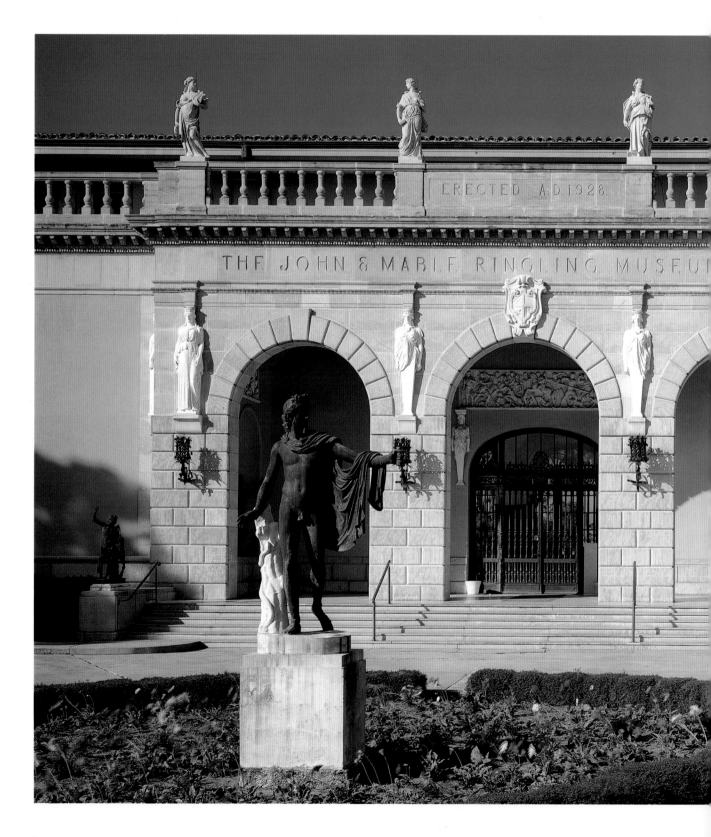

The John and Mable
Ringling Museum of Art

CONTENTS

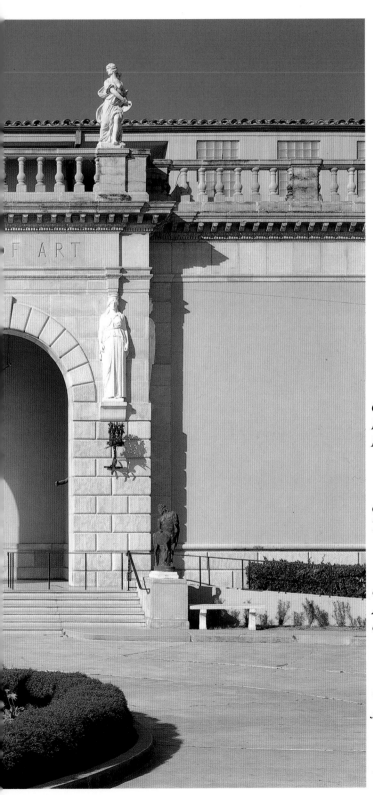

Piero di Cosimo The
Building of a Palace,
*c. 1515-1520, oil on
panel (detail).*

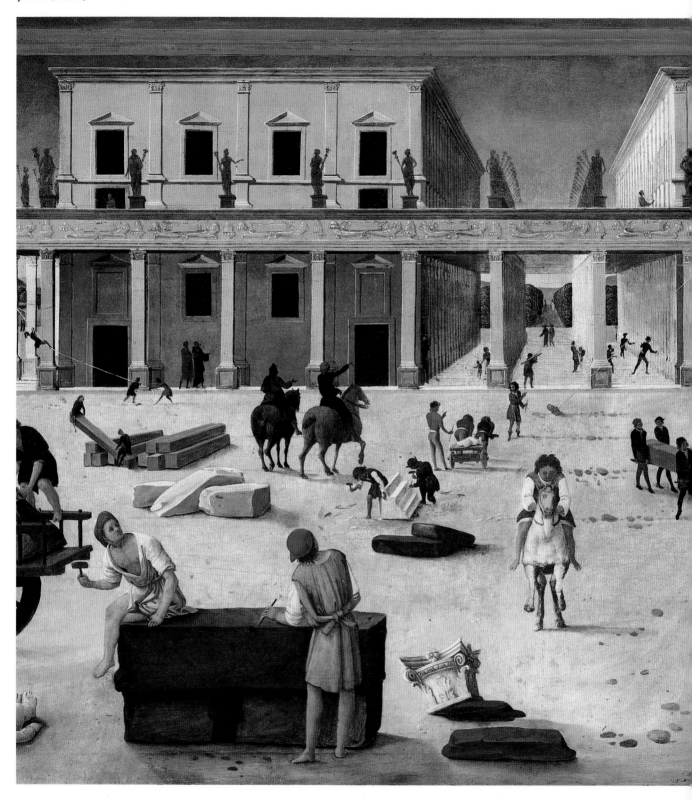

INTRODUCTION

For more than half a century, The John and Mable Ringling Museum of Art has been the cultural mecca of Florida, a magnificent memorial to the vision and munificence of its founder.

In a setting of serene, natural beauty among palms and native pines on the shore of Sarasota Bay, the Museum is an enclave of artistic wealth, European elegance, and intriguing architecture. The original Museum building—an Italian Renaissance villa—surrounds a

lovely, landscaped courtyard, replete with fountains and historic statuary, and contains an extraordinary collection of Old Master paintings.

Prior to his death in 1936, John Ringling had amassed the largest privately-owned collection of Peter Paul Rubens in the world, and the Museum is internationally noted for its extensive collection of fine Baroque paintings—the imposing, brilliantly colorful, dramatic compositions of the 16th and 17th centuries. In 1986, representative paintings from the Baroque collection were exhibited for six months in the National Gallery of Art, Washington D.C., at the invitation of the Gallery's director, Dr. Carter Brown, who described them as "simply magnificent."

The Museum's other art treasures include a major group of Cypriote objects, European and American prints and drawings, tapestries, sculpture, architectural antiquities, jewelry, decorative arts, and a contemporary collection.

Housed in separate structures are the Asolo Theater, adjacent to the north wing of the art galleries, and the Museum's collection of circus memorabilia. The Asolo Theater interior—an 18th century Italian court playhouse—was acquired by the State of Florida in 1949. Originally installed in a castle at Asolo, near Venice, the dismantled theater was shipped to Sarasota and reassembled at the Museum. It is the only original Baroque theater in the United States and, with a full schedule of theatrical performances, art films, and lectures, has the additional distinction of functioning as an exhibit-in-use.

The Circus Galleries are a 1948 addition to the Museum complex. This building, located a short walk from the art galleries, was expanded from the original Ringling garage, which once held a fleet of Rolls-Royces and Pierce-Arrows, and now displays colorful, carved wagons. Included among the galleries' nostalgic memorabilia are rare circus posters, spangled costumes, and tow-

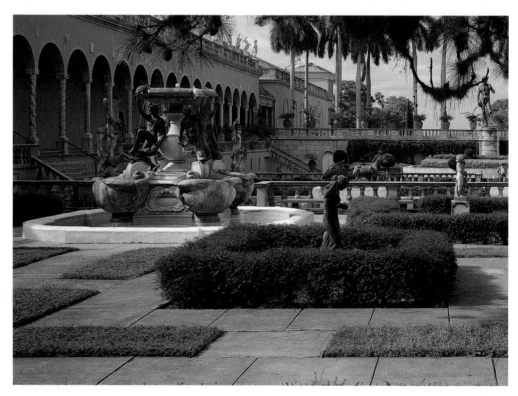

RIGHT: Museum Court-yard showing The Fountain of the Tortoises *20th century, marble and bronze copy of 16th century original. FAR RIGHT: Wrought iron gates to Museum entrance court.*

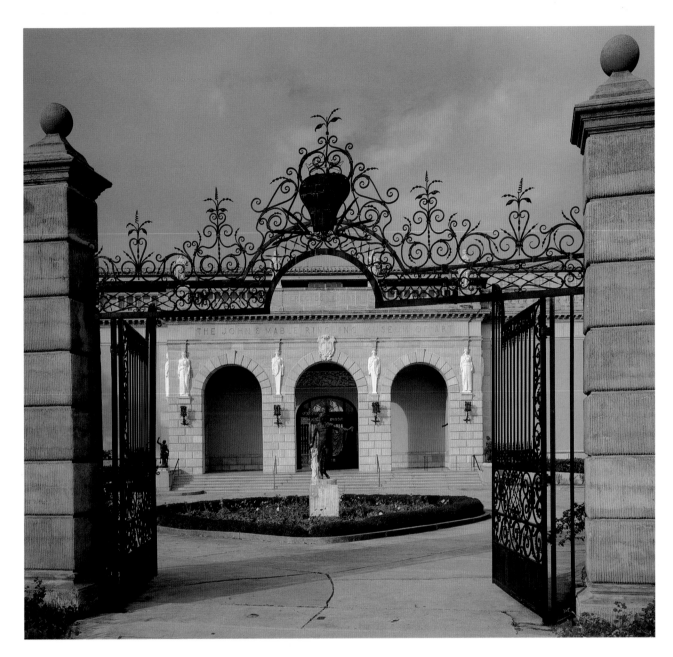

ering, jeweled headpieces.

Overlooking Sarasota Bay at the end of a winding, tree-lined drive is the Ringlings' winter residence, Ca' d'Zan, an exotic Venetian palace with a 200-foot marble terrace leading to a landing platform at the water's edge. Designed by New York architect Dwight James Baum, the Ca' d'Zan is a particularly colorful and exuberant example of American decorative architecture of the 1920s. Completed in 1926, and still containing much of the original furniture, this splendid mansion now provides the setting for many of the Museum's decorative art objects, along with a fascinating glimpse of the lifestyle and creative spirit of its owners.

Near the house is Mable Ringling's rose garden, and throughout the grounds are lush examples of tropical foliage—flaming hibiscus blossoms, botanical rarities like the sausage tree, and gnarled banyan trees with their strange complexes of aerial roots.

The 66-acre estate bequeathed to the people of Florida lies west of the old Tamiami trail (U.S. Highway 41), at the northern gateway to the city, and is part of the original landholding bought by John Ringling in 1912.

In the early part of this century, Sarasota attracted a number of prominent visitors who found it a paradise of sport fishing and boating, as well as a refuge from northern winters. The Seaboard Airline Railroad had extended its tracks into the village in 1904, and accessibility by rail, as well as by water, made this gulf coast area additionally attractive. A few of the wealthy vacationers built

spacious winter "cottages" and began to invest in property.

Among the early investors were men with railroad and circus interests, whose enthusiasm prompted John and Mable Ringling to make a visit to Sarasota in 1911. Early the next year, the Ringlings bought a piece of land several miles north of the city with more than 1,000 feet on the water, and a charming frame house with a gabled roof and wide verandas. The house remained their winter home for more than a dozen years, until it was moved to prepare the site for the building of Ca' d'Zan.

John Ringling, one of the founding partners of the Ringling Brothers' Circus, was a man of diverse business interests, and an enthusiastic patron of the music and art he loved. A collector of paintings for many years, his ultimate achievement was The John and Mable Ringling Museum of Art, with its priceless works, which, from the beginning, had been devised as a gift to the people of his adopted state. His generosity in creating this memorial to himself and his wife is a nearly unprecedented act of altruism.

"John Ringling...with all his quiet every day ways is a genius," wrote columnist Dr. Sam Small of the Atlanta Constitution in March 1930, "...Under his hat is a brain fertile with ideas of usefulness to all humanity and under his shirt front is a big heart that covets the satisfaction of having enriched the people who have enriched him."

Following the circus magnate's death in 1936, extensive litigation prolonged the settling of his Estate, and it was 10 years before Florida accepted its inheritance. Then-Governor Millard Caldwell headed the state delegation at a ceremony held in the courtyard of the Museum on February 9, 1946.

"In the name of Florida and in grateful memory to John Ringling, I accept the home and museum and treasures he gave to the people, and promise that we will make the best use of them," said the Governor.

Officially designated The State Art Museum of Florida, The John and Mable Ringling Museum of Art was initially overseen by the State Board of Control, which later gave way to a Board of Trustees appointed by the Governor. The Museum is now supported by a vigorous partnership of the State of Florida and a diverse group of generous contributors through its private support group, The John and Mable Ringling Museum of Art Foundation.

From 62,000 visitors in its first year of state operation, the Museum now is host to well over 300,000 people a year, and additionally sends out a wide variety of exhibitions, which circulate throughout Florida. The Museum loans its exhibitions and objects from its collections throughout the world to such institutions as the Metropolitan Museum of Art in New York City, the European Palais des Beaux Arts in Brussels, and the National Gallery of Modern Art in Rome.

The Museum has a fine art library housing 150,000 volumes, which is available to area residents, students, and scholars; the Education and Special Activities departments plan a full, year-round schedule of programs for the benefit of the general public, families, and Museum members.

It is the stated mission of the Museum to promote excellence in the institution worthy of the quality of the collection, to provide cultural and educational leadership in the State and region, and to share the magnificent legacy of John Ringling with all Floridians and, indeed, all who share a love of art.

RIGHT: Bayside view of Ca d'Zan from south lawn.

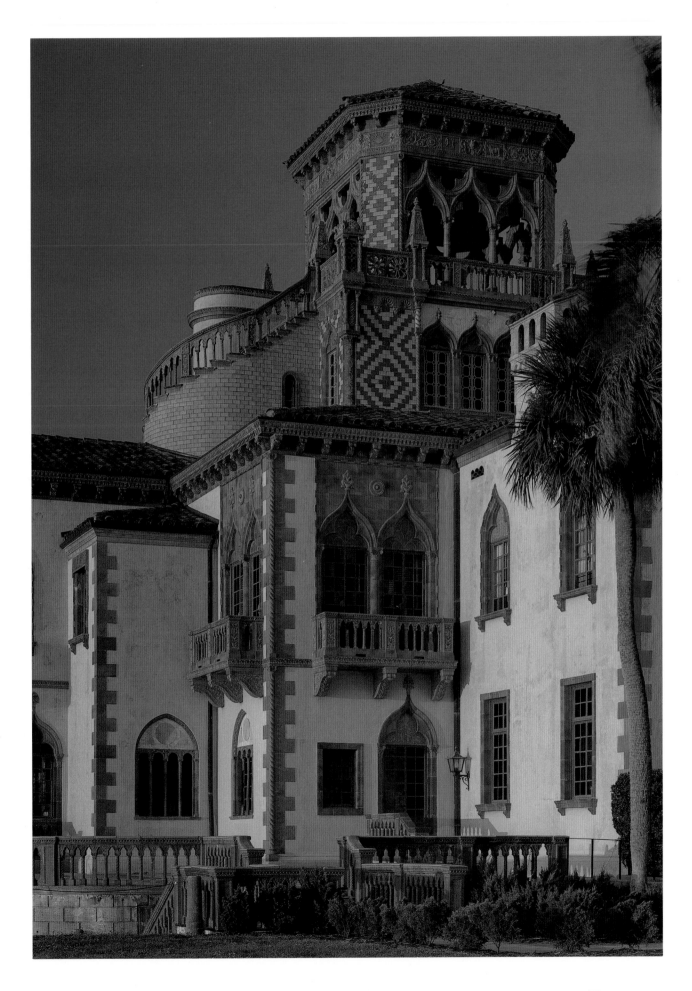

Peter Paul Rubens Abraham and Melchizedek, *c. 1625, oil on canvas (detail).*

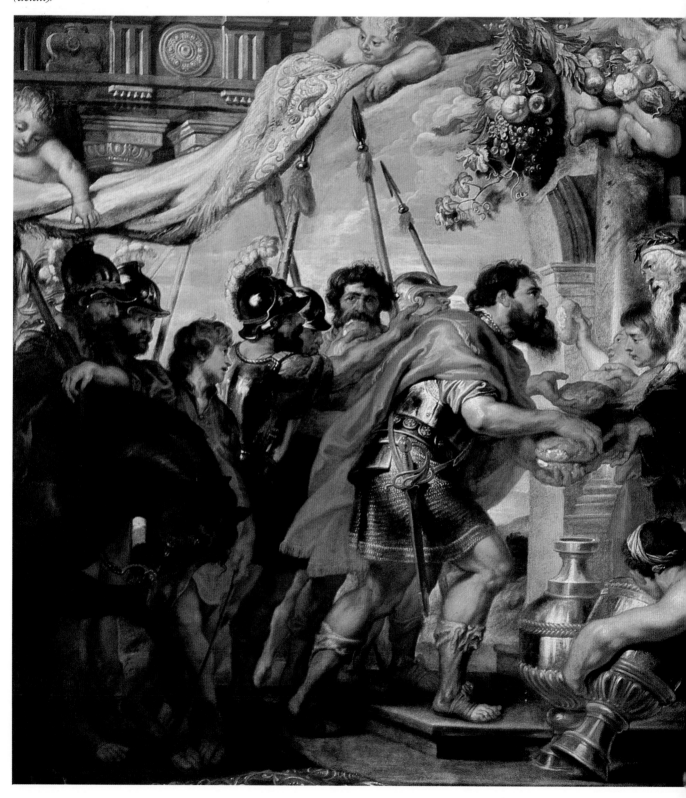

THE COLLECTIONS

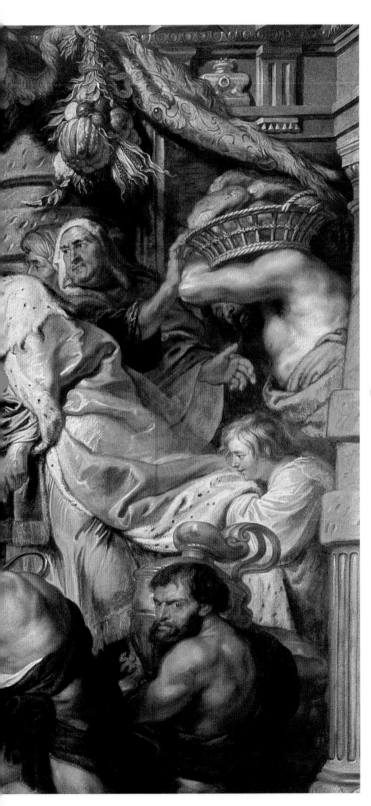

On March 1, 1931, the lead story in the Sarasota Herald began: "The John and Mable Ringling Museum of Art will be open tomorrow.

"A short phrase, and simple, but behind it what a wealth of meaning. Thirty years of collecting pictures, and behind that, five centuries of creating art by men whose names and work will live for thousands of years to come ... The John and Mable Ringling Museum of Art will take its place among the great temples of art

(and) Sarasota will be known the world over as the city of Ringling Museum."

Since becoming the state art museum in 1946, John Ringling's original bequest, which included 625 paintings, has been augmented through purchases and gifts to a current listing of over 10,000 accessioned objects. There are now more than 1,000 paintings, 2,500 prints and drawings, 24 tapestries, 400 pieces of sculpture, 2,200 pieces of Cypriote art, 1,500 decorative art objects, 800 Greek and Roman objects, and 200 miscellaneous works.

Additionally, some 1,400 artifacts are located in the Ringling mansion—Ca' d'Zan—and at the Circus Galleries. But the heart of the collections continues to be the magnificent group of Baroque paintings, most of which were bought by John Ringling. Marked by beauty, rich color, and often epic character, the opulence and splendor of 17th- and 18th-century art were innately compatible with the richly imaginative collector.

"...The gift of showmanship, the energy, the vitality, the enthusiasm which has made the circus thrilling are excellent qualifications for the man who would meet the old masters on familiar terms," wrote an interviewer in The Art News in 1928. "It is quite natural that great scale should be one of the foremost attributes of Mr. Ringling's

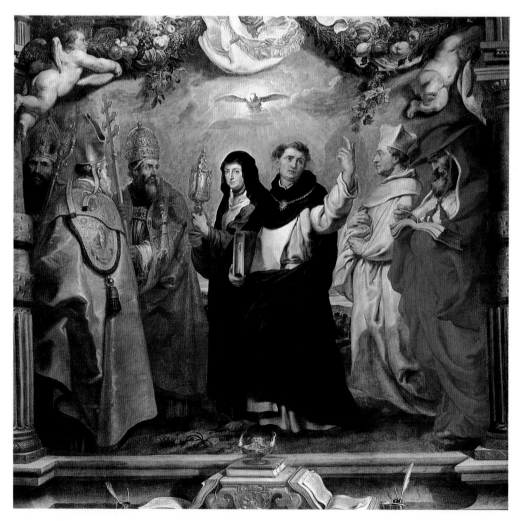

RIGHT: Peter Paul Rubens The Defenders of the Eucharist, c. 1625, oil on canvas. FAR RIGHT: Peter Paul Rubens Portrait of the Archduke Ferdinand, 1635, oil on canvas (detail).

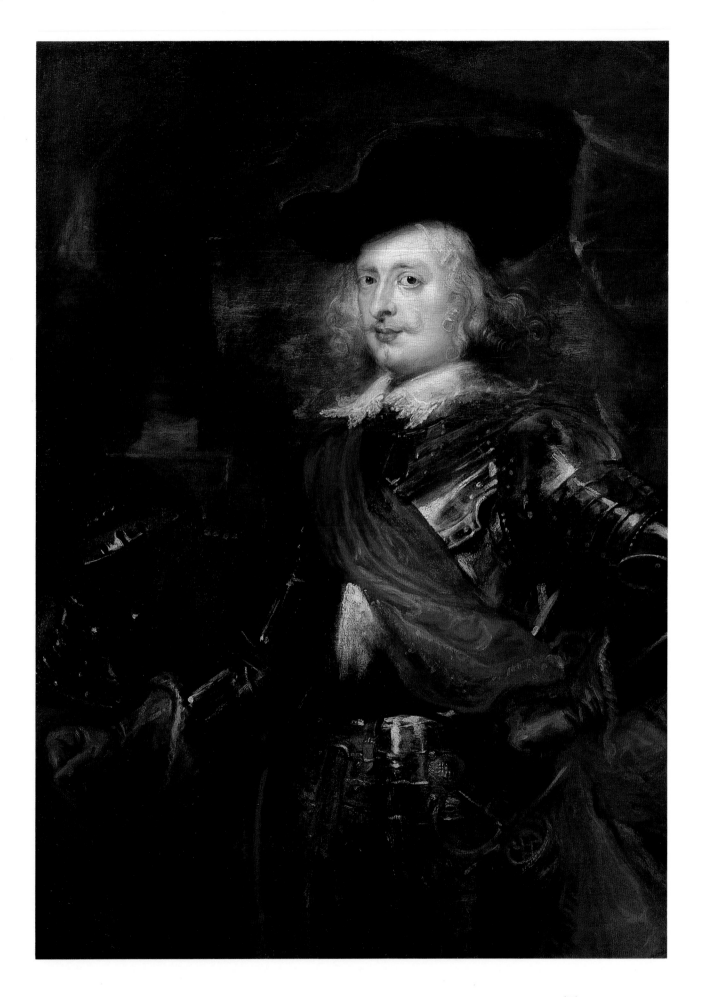

museum - huge galleries, enormous pictures, imposing names."

Among those names is Peter Paul Rubens, and in the gallery designed to house them, the monumental, wonderfully colorful Rubens cartoons are a spectacular display and represent a unique treasure. Commissioned in 1625 by the Hapsburg Archduchess Isabella, the paintings served as patterns for a series of tapestries, The Triumph of the Eucharest, woven for a Carmelite convent in Madrid where they still hang.

When the tapestries were completed, at least some of the 11 cartoons are thought to have been displayed for the pleasure of the Archduchess in the royal palace at Brussels. Following her death, six were sent to Spain and the remainder were presumed destroyed in a palace fire. Four of the paintings in the Museum's collection were bought by John Ringling in 1925 from a descendent of the Duke of Westminster, who acquired them in Madrid in 1818. The fifth, The Triumph of Divine Love, was discovered

in England in 1976 and obtained by the Museum in 1980.

Also in the collection are Rubens' *The Departure of Lot and His Family from Sodom* (in the original bequest), and *Portrait of the Archduke Ferdinand*—a 1948 purchase.

While chairing a Museum survey committee in 1953, Francis Henry Taylor, then-Director of the Metropolitan Museum of Art, described the Ringling collection of Rubens as "...unrivalled in any American museum" and praised the Museum's holdings of "masterpieces celebrated throughout the world."

Other major Northern European artists represented in the galleries are Lucas Cranach the Elder, Anthony Van Dyck, Jacob Jordaens, Jan Davidsz. de Heem—a master of still life painting—and the great 17th-century portraitist, Frans Hals, whose painting of *Pieter Jacobsz. Olycan* in the Ringling collection is regarded internationally as one of his masterpieces.

The Museum is particularly strong in its

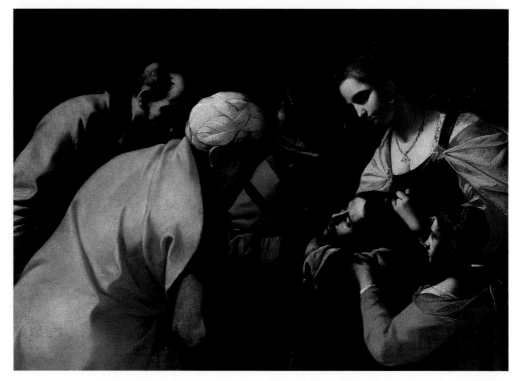

RIGHT: Mattia Preti Salome with the Head of John the Baptist, *c. 1648, oil on canvas. FAR RIGHT: Frans Hals* Pieter Jacobsz. Olycan, *c. 1639, oil on canvas (detail).*

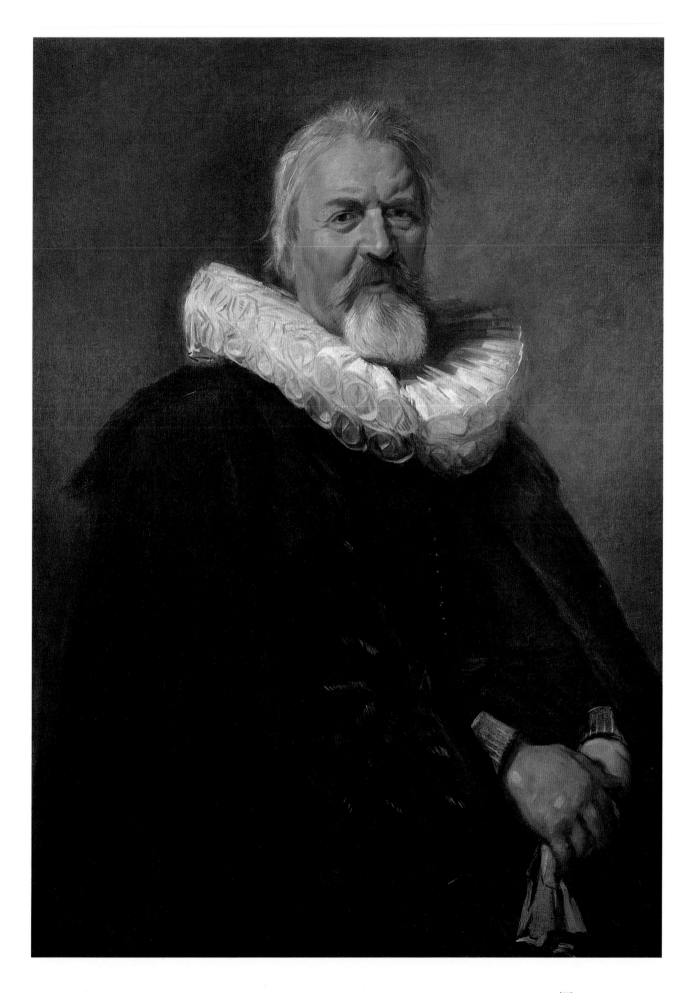

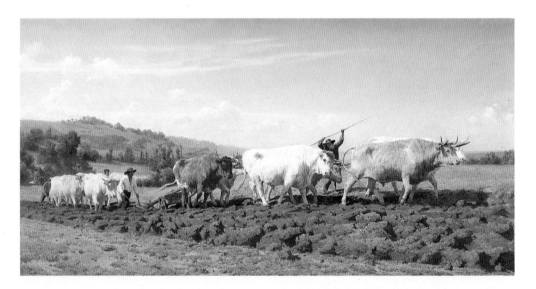

Italian Baroque collection, which includes every important school of Italian painting between 1550 and 1765. Here are works by Luca Giordano, Bernardo Strozzi, Pietro da Cortona, Salvator Rosa, Guercino, Panini, Guardi, Tiepolo, and Veronese, whose *The Rest on the Flight into Egypt*, a superb composition done in striking reds and blues, is one of the most beautiful paintings in the galleries.

The vivid *Salome with the Head of John the Baptist*, by the 17th-century Neapolitan artist Mattia Preti, was the Museum's 1985 major acquisition.

Important Italian paintings from other periods, such as Piero de Cosimo's early 15th-century *The Building of a Palace*, a perennial favorite of Museum visitors, complement the Italian Baroque collection.

Completing the period holdings are the paintings by other prominent European artists, including such distinguished works as Anton Raphael Mengs' *The Dream of Joseph*, Angelica Kauffman's *Sappho*, and *Hagar and Ishmael in the Wilderness* by Karel Dujardin.

An elegant *The Holy Family with Infant Saint John* by Nicolas Poussin, and Simon Vouet's superbly sensual *Mars and Venus*, represent two of the foremost French painters of the 17th century. Among the great Spanish artists represented with works are Ribera, Velasquez, and El Greco.

The largest of Thomas Gainsborough's known works, a huge equestrian portrait of *General Philip Honywood*, and Joshua Reynolds' *Portrait of the Marquis of Granby*, are highlights of the English collection, which also includes paintings by Joseph Wright of Derby, Allan Ramsay, and others.

Although Ringling concentrated on the Baroque era, he did make purchases out of the period, and the 1850 Rosa Bonheur oil *Ploughing in Nivernais* is one of the Museum's prized works. This painting was among those taken to Washington for the Ringling art exhibition in 1986.

In the New Wing Galleries—an addition completed in 1966 at the west end of the south wing—the Museum exhibits its Contemporary collection, a second area of acquisition interest. Presently, the holdings include sculpture by Joel Shapiro and John Chamberlain, and paintings by Philip Pearlstein, Frank Stella, Richard Anuskiewicz, Gene Davis, and Jack Beal, among others. There is also a fine group of photographs and other works on paper.

In 1974, The Museum purchased a *Salome*, by Robert Henri of the American Ash Can School, and in 1976, a painting by Henri's pupil, Reginald Marsh. These works customarily are hung with the period collec-

ABOVE: Rosa Bonheur Ploughing in Nivernais, *1850, oil on canvas. FAR RIGHT: Simon Vouet* Mars and Venus, *c. 1640, oil on canvas.*

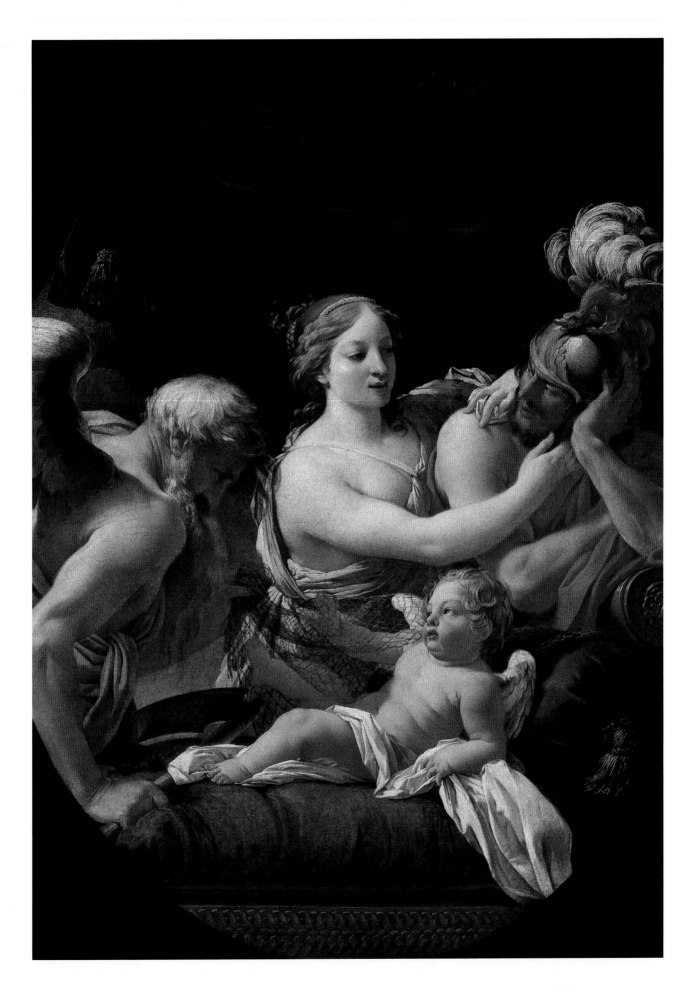

ABOVE: Cypriote Antiquities, from left, Hellenistic, Proto-Cypriote (600-540 B.C.), Neo-Cypriote (560-520 B.C.), male heads, limestone. FAR RIGHT: Paolo Veronese The Rest on the Flight into Egypt, c. 1566-1568, oil on canvas (detail).

tion. Other 19th- and 20th-century accessions of paintings, drawings, and prints include works by Marcel Duchamp, Thomas Hart Benton, and Arthur Dove, and—among the sculpture—a small Rodin bronze and fullsize female figure, also bronze, by Gaston Lachaise.

As Florida's official art museum, the Ringling has a particular interest in artists who make their home in the state. Longtime Sarasota resident Syd Solomon, who is represented in the modern collection, was instrumental in the establishment of children's art classes at the Museum in the 1950s. The late Jimmy Ernst, who had a home and stuido near Sarasota, also is represented.

Antiquities from the Isle of Cyprus form another of the Museum's rare and important collections. In 1928, the New York Metropolitan Museum of Art decided to deaccession the duplicates from its fabulous Cesnola Cypriote collection. These ancient objects, some of them 3,000 years old, were found by the 19th-century Italian archeologist, Luigi Palma di Cesnola, for whom the collection is named.

In acquiring several thousand of these items, Ringling brought to his Museum the second largest collection of Cypriote antiquities in the United States, and originally planned a separate building to house it. Included are freestanding statues, household utensils, jewelry, decorative accessories, and items of religious significance.

Not all of the objects Cesnola found were made on Cyprus; the collection has great variety, and among other pieces are black and red Athenian pottery from the fifth century B.C., Corinthian pieces, Roman glass objects dating from 100 B.C. to 400 A.D., and 13 wine jars made on Rhodes, which shipped wine throughout the ancient Mediterranean region.

The astuteness and foresight of the collector also is reflected in the period rooms housed in Galleries 19 and 20. These 19th-century interiors were bought from the New York mansion of John Jacob Astor when the house was demolised in the mid-1920s. The paneled rooms, notable for their elaborate gilt moldings, painted panels, and rococco settings, were created by Julius Allard and Company of Paris and New York in the early 1890s, when Astor's mother, Mrs William Backhouse Astor, built the house on Fifth Avenue at 65th Street.

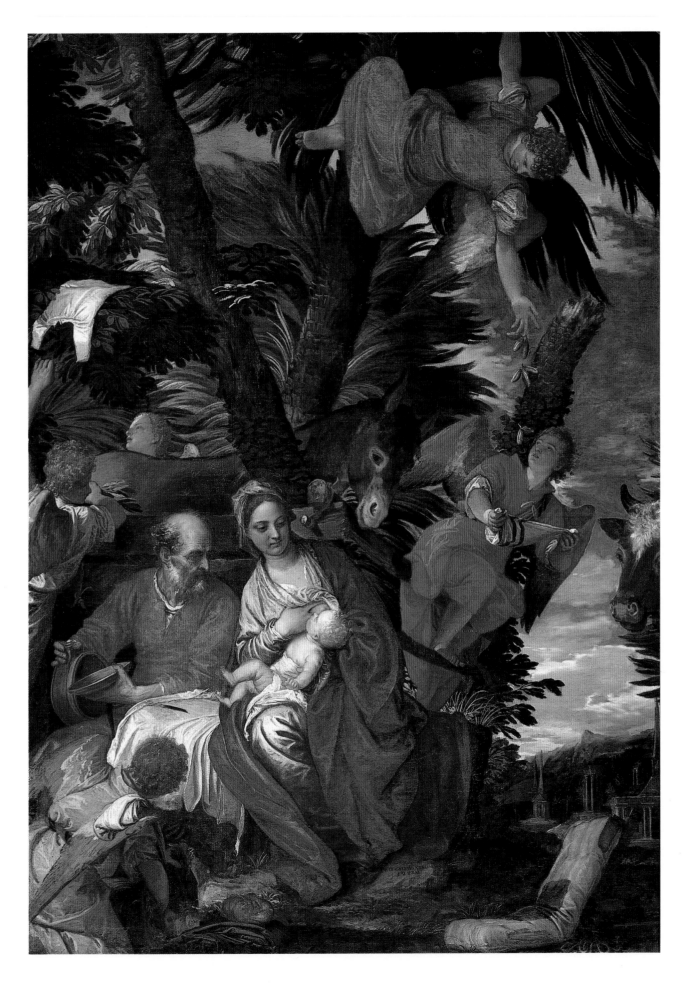

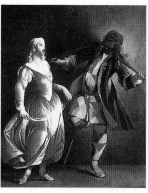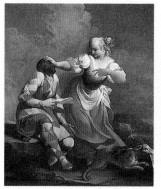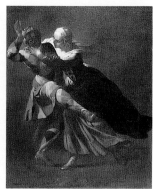

Following a history of Puritan ethic in American architecture, the end of the 19th century saw the introduction of French decorative styles—elegant, opulent and grand—in the great houses of American millionaires. In the 1920s, such houses began disappearing, and in buying the mirrored Astor reception room (Louis XV) and oak paneled dining room (considered Louis XIV), Ringling again revealed a sense of preservationism, along with a taste for historic treasure.

In its own building at the west end of the north wing galleries, the Museum's other historic "period room" - the baroque Asolo Theater - delights visitors with its ornate decoration, tiers of boxes, and portrait medallions. There are nine of the latter and Queen Catherine Cornaro, the only queen in the history of Asolo, Italy, is the central figure.

In 15th-century Venice, Catherine, daughter of a wealthy merchant, was chosen to become the bride of the King of Cyprus with whom the Venetians were forming an alliance. She was widowed in 1473, a year after her marriage, and when the republic of Venice annexed the island, Catherine was given the hilltown of Asolo for her court. Her 20-year reign was notable for its emphasis on culture and elegance, and in 1797, nearly 300 years after her death, the theater was built in the castle and dedicated to her memory.

The other medallions memorialize famous Italian poets and dramatists—Dante and Petrarch among them—and additional, symbolic, figures in the decor seem to suggest groups of happy spirits in a theater. The great Eleonora Duse is among the actors recorded as performing in the theater in its castle setting, and poet Robert Browning and French novelist George Sand both wrote about it.

Art works displayed in the Asolo Theater building include a series of Harlequin paintings by the 18th-century Italian master Giovanni Ferretti.

The Museum's collection of decorative arts is an eclectic assortment of objects: individual pieces acquired by John and Mable Ringling on their travels, whole collections bought from dealers or at auction, and subsequent state purchases and gifts.

Decorative objects from the collections

ABOVE: (from left): Giovanni D. Ferretti Pulcinella with a Pot, Harlequin as Dancing Master, Harlequin as Rejected Lover, Harlequin Attacked *(from* Disguises of Harlequin), *18th century, oil on canvas. RIGHT: Interior view from stage of Asolo Theater. FAR RIGHT: Robert Henri* Salome, *1909, oil on canvas (detail).*

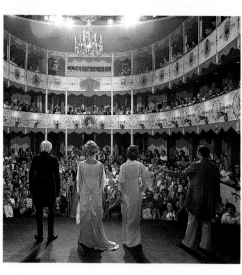

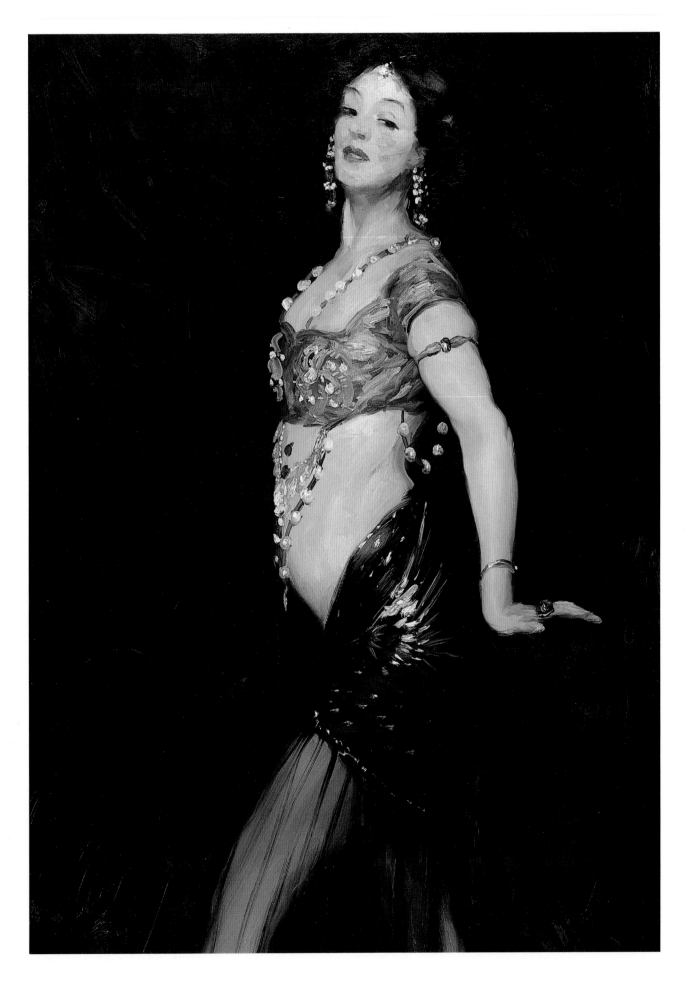

are found in all of the buildings of the Museum, and a particular highlight at Ca' d' Zan is the carved walnut *trono* (an Italian Renaissance bench seat), made in 1508 for the Strozzi palace in Forence and bought by John Ringling in 1927. Also lovely are the pieces of Italian maiolica (tin-enamelled earthenware), which are among many beautiful objects Ringling acquired when he bought the famed Emile Gavet collection of decorative arts from the estate of Alva Vanderbilt Belmont. From the same Parisian collection are the Museum's exquisite wax portrait medallions.

The assortment of memorabilia housed in the Circus Galleries ranges from rare 18th-century prints and colored drawings to glittering, spangled costumes, and brightly painted, carved wagons. There are also choice 19th- and early 20th-century posters, props used by famous performers, and such curiosities as Tom Thumb's walking stick and carriage. An excellent library of circus history and literature includes newspaper clippings dating as far back as 1816. All of this material—much of it donated—has been assembled since 1946, following a State decision to add a circus collection. Until the complete redesigning of the Galleries' building in 1988, some of the collection (held for safekeeping in the vault) had never been on display.

Decorating the Museum's landscaped courtyard are many copies of classical Renaissance and Baroque sculpture. Ringling bought sculpture practically by the boatload, great quantities of garden sculpture, as well as copies of world-famous pieces. Visitors particularly enjoy the *Fountain of Oceanus* and the *Fountain of the Tortoises* (the originals of both may be seen in Italy today), and children love the prancing horses pulling a chariot dedicated to the goddess Ceres. The bronze David dominating the west bridge is a copy of Michelangelo's famous marble statue in Florence, Italy.

At the entrance to the Art Galleries, the

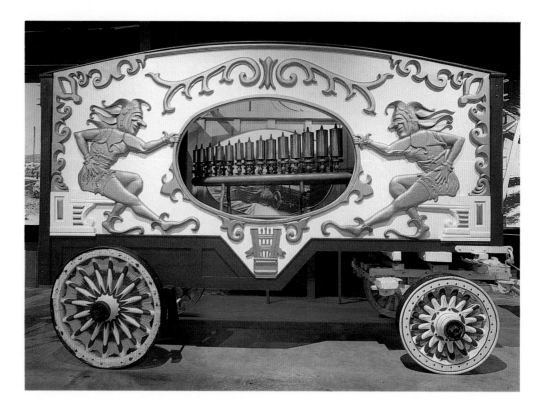

RIGHT: Two Jesters *steam calliope, 1920. FAR RIGHT: Maiolica drug vase, early 16th century.*

sculpture of *Lygia and the Bull* is a 20th-century original by Italian-American sculptor Giuseppe Moretti who based it on characters in Henry Sienkiewicz's 1895 novel *Quo Vadis*. Originally intended for the city of Philadelphia, the bronze piece was bought by John Ringling in the late 1920s when the city fathers disagreed over the sculpture's propriety and removed it from public display.

The many and varied objects in the permanent collection of the John and Mable Ringling Museum of Art include numerous works suitable for traveling exhibitions. About a fourth of the Museum's prints and drawings are on display every year in cultural, civic, and educational institutions throughout Florida as part of the Museum's Circulating Exhibitions Program.

In recent years, requests from other institutions have resulted in the loan of paintings to, among others, the Metropolitan Museum of Art, the Wadsworth Atheneum, the Pinacoteca Nazionale in Bologna, the Europalia Palais des Beaux Arts in Brussels, and the National Gallery of Modern Art in Rome, as well as the National Gallery of Art in Washington, D.C. However, some of the Museum's holdings—like the Rubens cartoons—are too large (and too precious) for safe travel, and other works may be deemed by the conservator to be too fragile.

Each year the Museum welcomes more than a third of a million visitors (many of them schoolchildren) to look at the collected masterpieces, reflect on their beauty and the continuity of human experience they record, and absorb the majesty and greatness of this art into their own experience.

In 1947, Karl Bickel, the late president of United Press International, a friend of John Ringling, and an original trustee of the Museum, remarked: "John Ringling gave the State a magnificent treasure...something far more vital and more potent in the molding and shaping of the mind and soul of the State in the future than many of us understand."

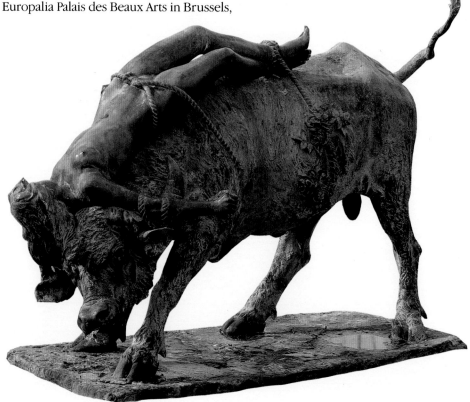

RIGHT: Giuseppe Moretti Lygia and the Bull, *c. 1920, bronze. FAR RIGHT: Museum Courtyard* Fountain of Oceanus, *20th century, marble and limestone copy of 16th century original.*

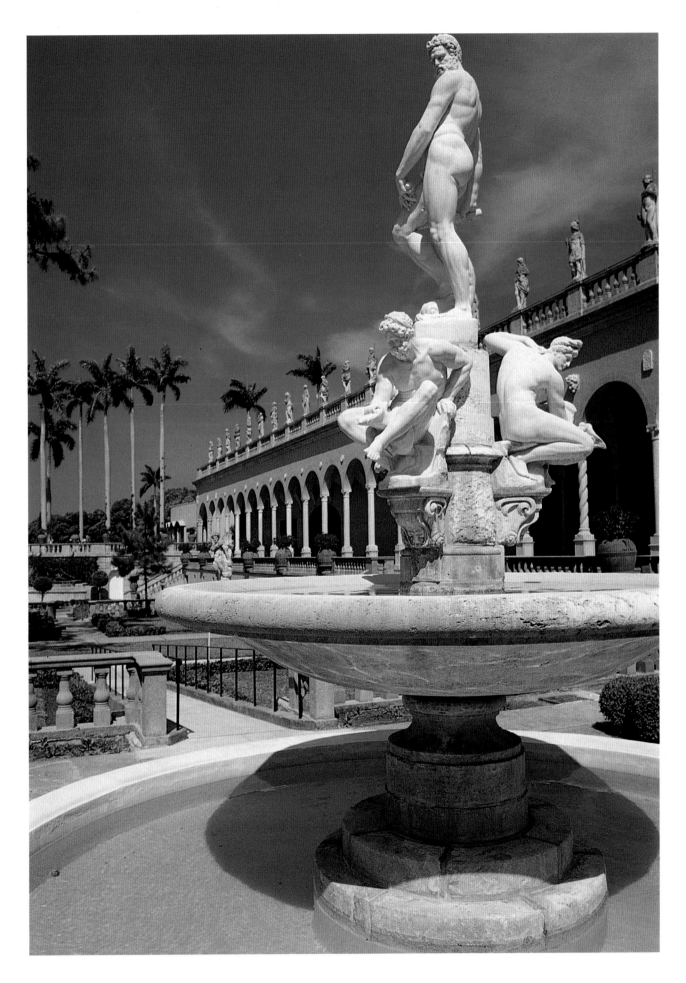

*Ca d'Zan, bayside view
from south.*

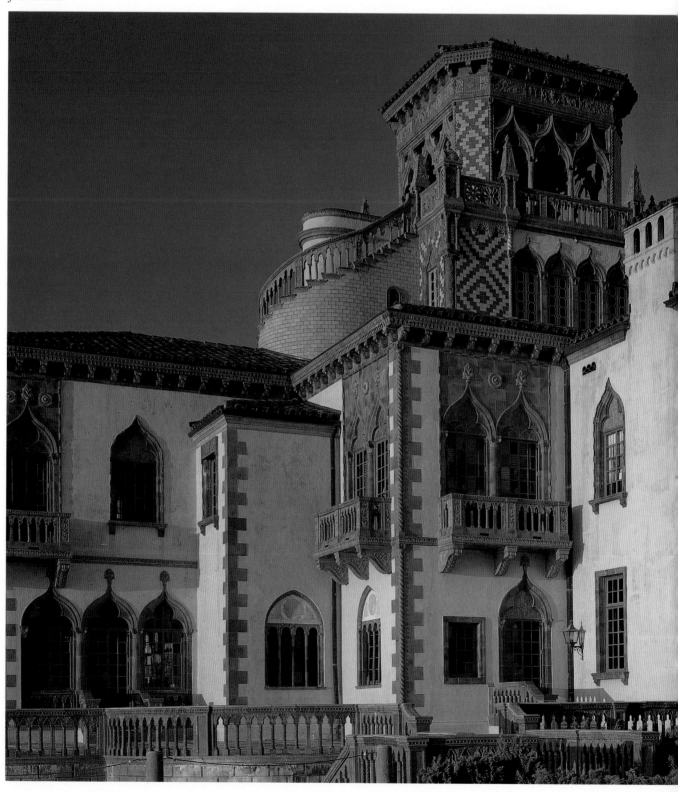

ARCHITECTURE AND ARTISTRY

Imaginative architecture in an exotic tropical setting is one of the memorable charms of the John and Mable Ringling Museum of Art. The embellished Venetian palazzo that served as the Ringlings' winter home and the Italian Renaissance villa, which was built to house their art collection, are a combination of classic, dramatic, and fanciful elements. This architectural fantasy adds a delightful, romantic quality to the Museum's environment and to the serene beauty of

the elegantly landscaped estate.

By the early 1920s, John and Mable Ringling had long been enchanted with Italy and in particular with Venice. The couple loved the architecture and the sunny Mediterranean colors, and Mable compiled a portfolio filled with photographs and sketches of features she wanted incorporated into the palatial home they were planning.

A number of American palaces boasting Italian or Spanish influence were built in the first quarter of the 20th century. Addison Mizner popularized Mediterranean Revival architecture in Palm Beach, and in Miami, James Deering built his Spanish-Italian-Renaissance-baroque Villa Viscaya. Overlooking the Pacific Ocean on the coast of California was William Randolph Hearst's sprawling hilltop castle, San Simeon.

Ca' d'Zan

Each of the major original buildings on the Ringling estate had its own architect and Sarasotan Thomas R. Martin —who had come from Chicago to design The Oaks for Mrs. Potter Palmer—was the first to work with the Ringlings on plans for Ca' d'Zan. Martin's son, Frank, a young architect in the office, did much of the original drawing. The Ringlings next consulted Dwight James Baum of New York, who is largely responsible for the development of the house as it now stands.

Dwight Baum was a prominent architect on the eastern seaboard at that time. In 1923, he was awarded the Medal of Honor of the Architectural League of New York for his "achievements in designing country houses." The architect's residential work, elegant and tasteful, was based primarily on colonial styles—a far cry from the Doge's Palace which inspired Mable Ringling. It is said that when the Ringlings presented Baum with their preliminary plans—which also included a tower based on the Italianate one of New York's original Madison Square Garden—the architect went pale!

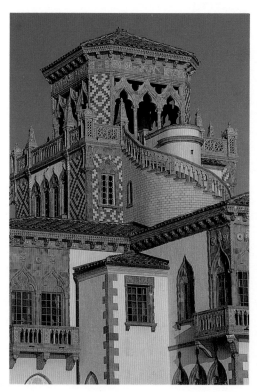

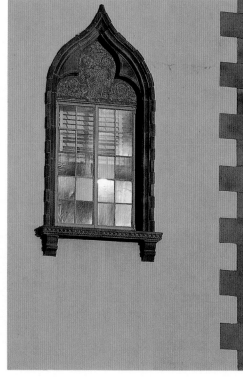

THIS PAGE: (left) Tower showing terra-cotta ornamentation; (right) Window detail. FAR RIGHT: Gargoyles appear in detail from tower.

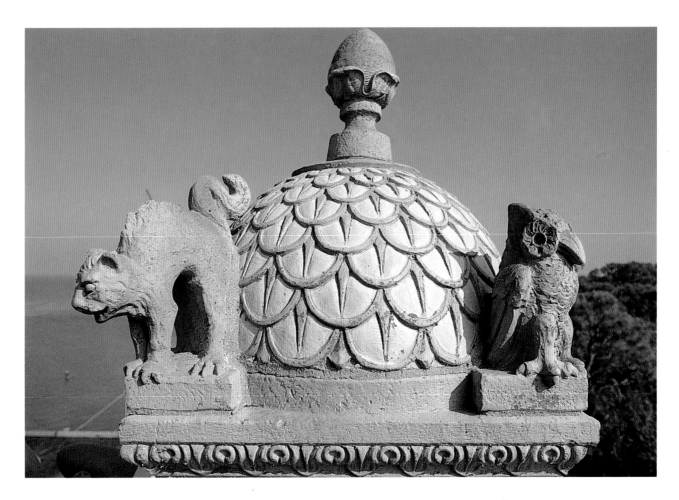

Elements of either the Venetian palace or the Garden's tower are minimal in the completed Ca' d'Zan. The mansion evolved with many changes of plans, and the result, built at a cost of $1,5000,000, is an eclectic ensemble of architectural details—with touches both grand and whimsical.

The west facade on Sarasota Bay, however, would be at home on the canals of Venice. Flanking the center section, with its seven pairs of French doors glazed with tinted glass, are wings with balconies, carved window frames, ornamental cornices and the like, all in Venetian Gothic style. The terrace, paved in domestic and imported marble, is approximately 200 by 40 feet, and steps, 25 feet wide, of English veined marble, lead to the lower dock where Mable Ringling tethered her gondola (imported from Venice), and guests could board John's 125-foot yacht, *Zalophus*.

All of the decorative work on the exterior of the palace, the surrounds of the doors and windows, the medallions, the balusters, the ornamental cresting of the roofline, and most of the tower, is executed in terra-cotta —some of it overlaid with brilliant glazes, which came from the molds and kilns of

Oram W. Ketchum at Crum Lynne, Pennsylvania. Mable Ringling made numerous trips to approve the colors, and Ketchum's terra-cotta work at Ca' d'Zan— interior as well as exterior—is considered among the finest ever done in this country.

The mansion's tower, built Turkish-fashion as an open kiosk, is reached by an open stairway and has a magnificent view of the bay and barrier islands. Authentic 16th-century tiles, imported from Barcelona, Spain, originally covered all of the roofs. (These tiles still may be seen on the guest house.)

On the east side of the mansion, the 61-foot-tall tower is faced with brick laid in a diaper pattern, reminiscent, again, of the Doge's Palace as well as the Madison Square Garden tower. A large marble swimming pool across from the entrance is marked by an antique marble sculpture and decorated with colorful, Spanish tiles. The main entrance, approached from a circular driveway, features massive, carved, walnut doors, 12 feet high.

The focal point of the 31-room house is the large living room, a central great room rising two-and-a-half stories to a coffered, pecky cypress ceiling, which frames an

inner skylight of colored glass. Ornamental painting of mythological figures and the signs of the zodiac decorates the ceiling, and from it is suspended a huge crystal chandelier, which originally hung in the old Waldorf-Astoria Hotel in New York City.

One wall of the room has an elaborately carved fireplace of imported Italian stone, and on the opposite wall is an Aeolian organ. Built on the premises at a cost of $50,000, the organ can be played both electrically and manually, and its 4,000 pipes are hung behind tapestries on the balcony above. (The music room of Charles Ringling's mansion, next door, also featured an Aeolian organ built by the same New York expert.)

The walls of the court are of textured plaster and the floor, like those of the large entrance foyer and other southside rooms, is of black Belgian marble and white Alabama marble set in checkerboard squares.

Black Italian walnut was used to panel the walls of the dining room and its plastered

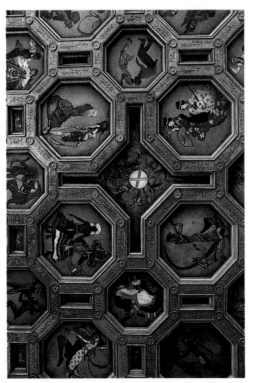

RIGHT: Ballroom ceiling features Dances of the Nations. *FAR RIGHT: View of central court showing overlooking balcony.*

ceiling is decorated with designs from unset cameos of the Gavet collection. Another extraordinary ceiling is in the ballroom where *Dances of the Nations* are pictured. The figures were created and painted by Willy Pogany, a costume and set designer for Ziegfeld's Follies. Pogany also did the ceiling of the third floor playroom, depicting the Ringlings and their pets among costumed revelers in a *Pageantry of Venice*.

Near the dining room, a small chamber of particular interest features the interior glass wall panels and bar of the Cicardi Winter Palace restaurant in St. Louis. It was one of John Ringling's favorite places, so he bought it and brought it home.

A marble staircase leads to the second story where a balcony runs around three sides of the court. The stairway spirals up to the playroom and the tower's paneled guest room, which was always the choice of Ringling's friend, American humorist Will Rogers.

The master suite on the second floor, decorated in French Empire style, has a bathroom of Siena marble, with gold fixtures. The owner's barber's chair is here, and on the bedroom ceiling is a painting of The Muses, which he bought in Paris. Black-veined marble floors and gilded door and window frames add to the grandeur. Mable Ringling's room adjoins her husband's and is appropriately delicate with Louis XV furniture of inlaid sandalwood.

There are five more guest rooms—each with a particular decorative style and tiled bath to match—and there were plenty of guests to fill them. The roster of visitors included many of the prominent industrialists, politicians, and celebrities of the era: Alfred Smith and James J. Walker—governor and mayor, respectively—of New York; New Jersey's Boss Hague; Phillips Petroleum founder, Frank Phillips; Albert Keller, head of the Ritz-Carlton Hotel; Florenz Ziegfield and his wife, Billie Burke; Julius Boehler of Munich, one of John Ringling's art dealers/consultants; humorist Irvin S. Cobb; John J. McGraw, owner of the New

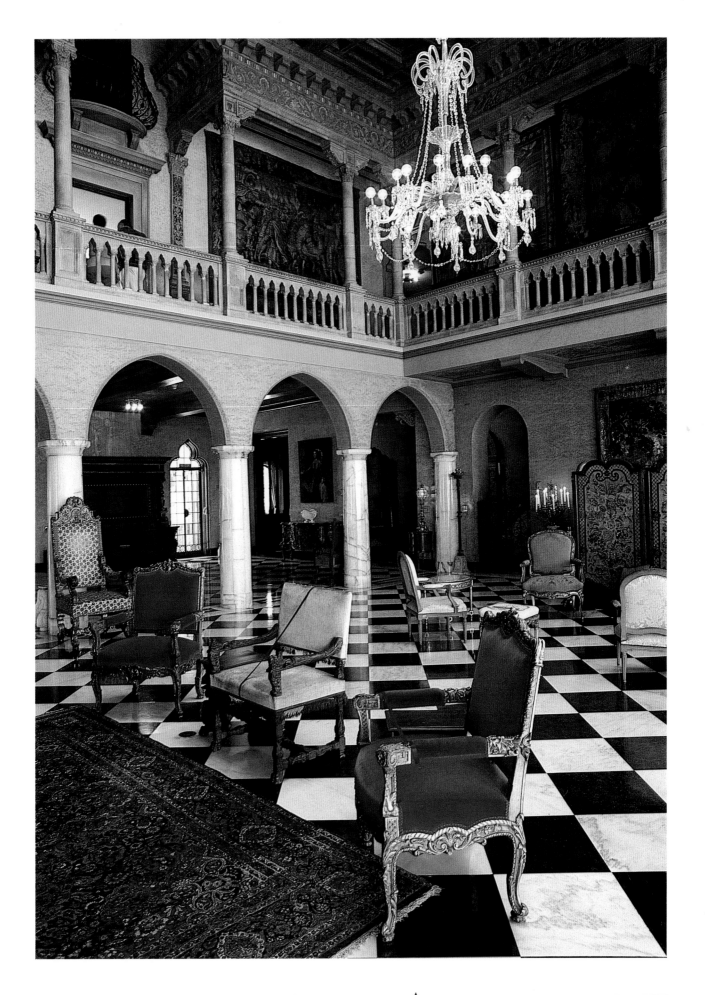

York Giants; sports promoter Tex Rickard; Karl Bickel of United Press; and body-builder Bernard Mcfadden, among them.

Ca' d'Zan, with its rosy stucco walls and colorful marble terraces gleaming in the sunshine, was built for vacations and for having fun. It was also intended to serve, eventually, as a museum for the Ringlings' Venetian art collection. Its architectural excesses—like the plans of its owner—are on a grand scale. Perhaps the ultimate assessment of Ca' d'Zan should be that bestowed on von Hildebrandt's design for Vienna's Belvedere Palace: "It is a victory of fantasy over logic, and the effect is enchanting."

The Art Galleries

John H. Phillips, who designed the Art Galleries building, was a man who shared the Ringlings' love of Italy. A graduate of the University of Wisconsin with a degree in civil engineering, Phillips achieved a national reputation as a designer long before he became an architect, and was known for his ingenuity. A travel scholarship enabled him to spend a year and a half in Europe—chiefly in Italy—and his particular affections were for Rome, Venice, and Florence.

While visiting friends in Sarasota, Phillips met Mable Ringling, who engaged him to design a guesthouse for Ca' d'Zan. (The Venetian Gothic cottage is on the right as one approaches the main house.) The success of this project led to the architect's commission for the Museum, which reflects his own enthusiasm for Italy and classical styles.

The base of the whole building is rusticated stone, with a tooled surface, and the walls are stucco. Stone also was used for the balustrades and cornice. Above the impressive main entrance with its three arches, the cornice is supported by marble caryatids, and above it stand figures representing Music, Sculpture, Architecture, and Painting. Antique Spanish tile was used for the roof above.

Of basically simple design, the lofty central lobby joins two wings which extend west toward the bay, and enclose a terraced courtyard 350 feet long by 150 feet wide. Galleries open off vaulted loggias running the length of the wings and at the west end is a marble-paved "bridge" linking the north and south loggias.

There are 28 enormous terra-cotta Italian oil jars, planted with blooming bougainvillea, set at intervals on a terrace two steps below the loggias; below and in front of the west bridge is a semi-circular reflecting pool with a terrace above planned for use as an outdoor stage. The courtyard is a natural amphitheater and has superb acoustics — the result of the rhythmic repetition of arches and columns and the manner in which the loggia walls act as sounding boards.

Inside and out, the Art Galleries building holds a fascinating complement of architec-

RIGHT: Ringlings depicted in Playroom ceiling by Willy Pogany. FAR RIGHT: (top) Inlaid sandalwood furniture in Mable Ringling's bedroom; (bottom) John Ringling's suite is French Empire style.

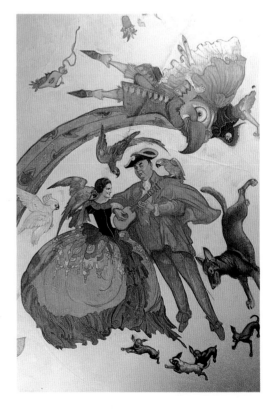

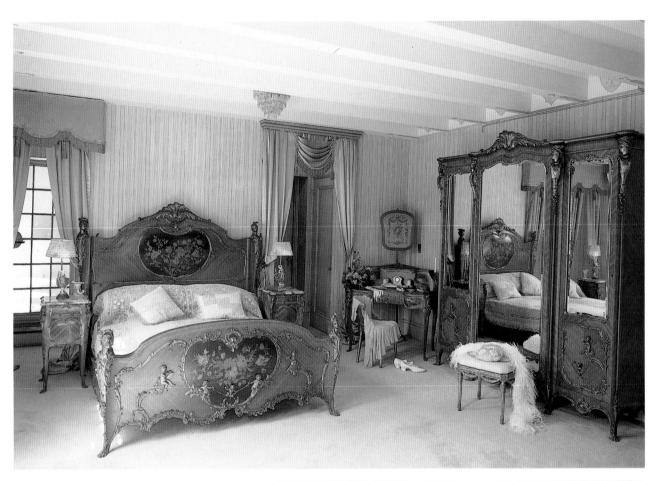

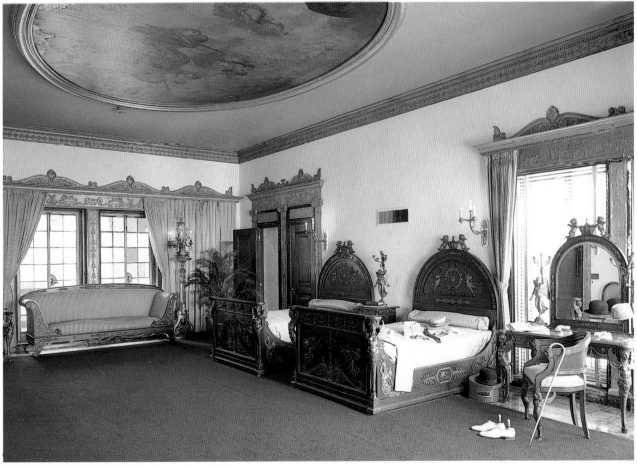

ARCHITECTURE AND ARTISTRY OF THE MUSEUM

tural and sculptural detail. There are inlaid marble mosaic doorframes, antique columns, wall fountains, statues, friezes, medallions, cartouches, and many kinds of doors, including a handsome bronze set said to be among the architectural elements John Ringling bought from the estate of his architect friend, Stanford White.

Of major interest and importance are the 91 antique columns—some of them dating to the 11th century—around the courtyard. Twelve of these were designated by Phillips as "unlike any found elsewhere in the world." The capitals are Ionic and four convex surfaces take the place of fluting. Four are placed at each end of the east loggia and the remaining four are set back under the loggias at the center, north and south. Also particularly fine are the six massive white Doric shafts on the inner edge of the loggia at the east end.

To solve the problem of symmetry with so many kinds of columns—and to bring them up to the same height—required consider-able inventiveness. Finally, the columns were mounted on brick pedestals, of varying heights, which then were covered with cast stone. The illusion is particularly successful.

Inside the galleries are many unusual elements from the groined vaults of the entrance foyer to the clerestory windows in some of the galleries, and the artistry in moldings and wainscottings. The teak floors in the Rubens Gallery were a special pride of John Ringling, who bought the wood in South America, had it shipped in small logs and sawed to size at the site. Throughout, a myriad of lovely details enhance the enjoyment of the museum and, like the elegant sculpture garden, are grace notes to the experience of the Museum's splendid collections.

Soon after its completion, art connoisseur Julius Boehler called the Museum "an architectural jewel," and through the years it continues to be one of the most beautiful museums in the world.

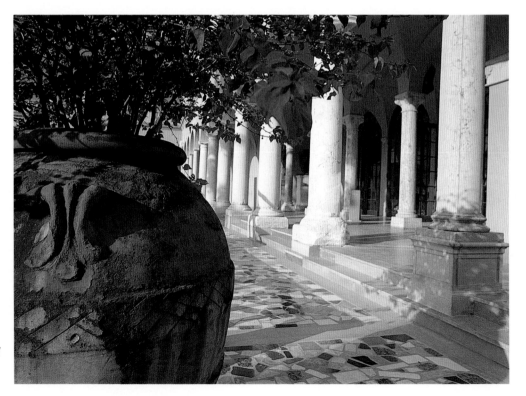

RIGHT: Italian oil jars serve as planters for bougainvillea. FAR RIGHT: The colonnaded Courtyard is a place of elegant tranquility.

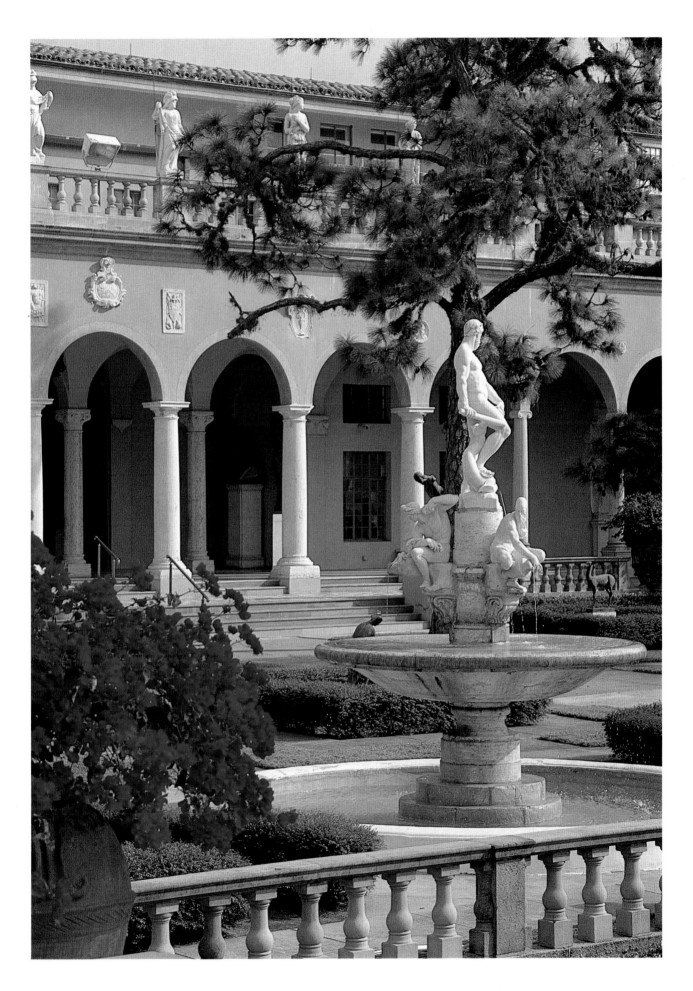

*The Ringling Family,
from left, standing,
Albert, Alfred, August G.,
Charles, and Otto;
seated, from left, John,
Marie Salome, August,
Ida, and Henry;
Baraboo, Wisconsin, c.
1892-94.*

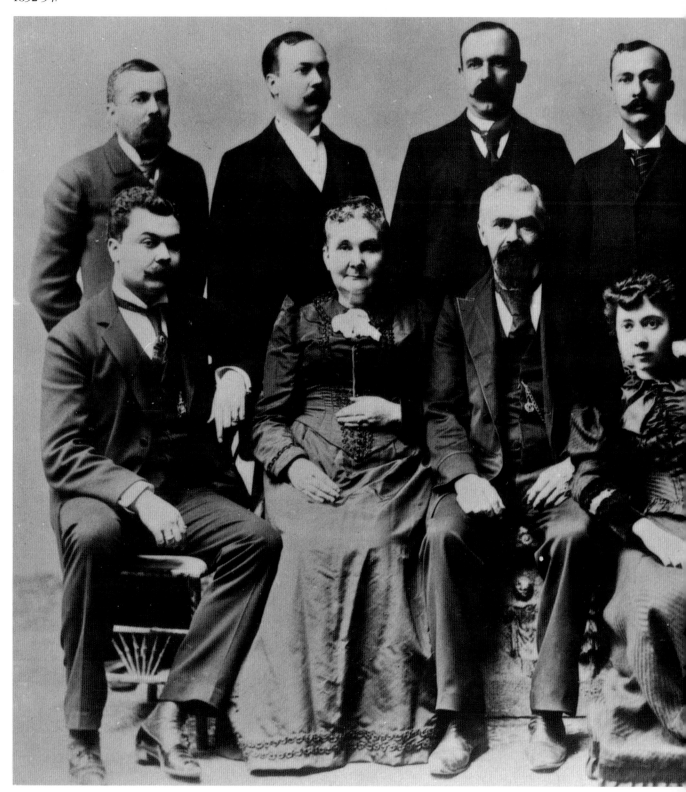

JOHN RINGLING

In 1911, when John Ringling made his first visit to Sarasota, he was already an international celebrity and a man of considerable wealth. As a businessman and developer, his contributions to his adopted community over the next quarter-century had more impact on the future of the area and the lives of its citizens than those of any other figure. Yet, he spent relatively short periods of time in Sarasota during those years, and few of its residents knew him personally. To

most of the populace, he was—and continues to be—something of an enigma.

A 1930 news story described the Museum founder as "...tall, with the chest of a sea elephant, the chin of a prize fighter and sensitive, artistic hands. There are several sides to John Ringling," the story continued. "He has an intense love of beauty, a keen sense of romance, a real appreciation of the arts. On the other hand, he is a keen, shrewd, hard businessman; practical to the extreme....Yet, he has the real showman's vision and imagination, and no man can be more courteous or more kind. He is a tough enemy, but a good friend, and many of the poor in this part of the country are witness to the size of his heart."

The complexity of John Ringling's personality was, along with his physical stature and talents, in part easily traceable to his forefathers. Like many self-made American millionaires, he was the son of European immigrants, and from his parents—who came to America in the mid-1840s—he inherited the mixture of French/German

RIGHT: Ringling Bros., 1898, Poster, Lithograph, Courier Company. FAR RIGHT: John Ringling, 1880s.

ancestry that is said to characterize a man fighting with himself all the time.

John's father, Heinz Friedrick August Rungeling, was born November 29, 1826, in Dankelshausen, Germany, and was descended from a French Huguenot family named Richelin who had taken refuge in Hanover during the religious persecutions of the early 17th century. At the age of 21, August emigrated to Canada, and a year later made his way west to Wisconsin, settling in Milwaukee, where he was soon joined by his parents and his sister Wilhelmina. (In Germany, the name Richelin had eventually become Rungeling. August "Americanized" it soon after coming to the United States, and the family was listed under the new spelling in the Milwaukee City Directory of 1851-52.)

Wisconsin also was the destination of Nicholas Juliar, a prosperous weaver and owner of vineyards in the French province of Alsace. In 1845, he sold his home and property and brought his wife and five children to Milwaukee where he bought a large farm a few miles northwest of the city. Juliar's second daughter, Marie Salome, then 20, and August Ringling were married in Milwaukee on February 16, 1852.

The young couple was well prepared to begin life together in their new country and had much in common. Both had studied English in school and could read and write the language well; additionally, Salome was fluent in her husband's German as well as in French. They shared a love of music and each of them carried the heritage of artisans. Salome, educated to be a gentlewoman, did beautiful tatting and needlework; August— following his formal schooling—had apprenticed to a saddler in Cassel, Germany, and was a skilled leather craftsman employed in a Milwaukee harness factory at the time of his marriage.

John Nicholas Ringling, born May 30, 1866, in MacGregor, Iowa, was the sixth surviving son of these parents. His father's search for an independent and prosperous situation resulted in a number of moves before he returned, in 1875, to Baraboo,

Wisconsin. Through the years, the family's fortunes varied between comfortable and desperately-hard times. Like his brothers, John was brought up with strict Lutheran values, great love of family, and in an atmosphere where artistry and integrity were prized. It was said of his father that there was nothing of which he was so proud as the excellence of his workmanship and the ideal of excellence was deeply imbedded in the Ringling sons.

Also from their father came the personal reticence for which John and his brothers later were known. The Ringlings were extremely private people who took life and business very seriously, and though ultimately engaged in a spectacular enterprise, the brothers maintained a quiet, dignified public posture and a marked formality in their dealings.

There are many apocryphal stories about the show business beginnings of the Ring-

lings, but John's career began in earnest in December of 1882 when he was 16 and joined three of his brothers who were then touring as "Ringling Brothers' Classic and Comic Concert Company."

"Love of music was inherent," John wrote in a 1919 article for *The American* magazine. "....We started out as a concert troupe of boys going to neighboring towns....We called it the Classic Concert Company' but soon changed it....Even that early we discovered there is something in a name and that the public's chief desire is to be amused rather than uplifted."

(The troupe was organized by the oldest Ringling son, Albert, who observed his 30th birthday in December of 1882, and by that time had more than 10 years' experience as a show manager. Two years later, he founded the circus with Otto, Alfred, Charles, and John as partners; by 1889 brothers August and Henry also were completely involved.)

Division of responsibility was one key to the Ringlings' success and when the circus began moving by rail in 1890, John, who had both a brilliant mind and a phenomenal memory, was put in charge of routing and railroad contracts. Soon he also was traveling regularly to Europe, establishing business connections and scouting for new talent. It was inevitable that during those trips he visited historic buildings and major museums and began to educate his long-standing interest in art. He had always had a keen visual sense—a good eye—which he mentioned in a 1931 interview with O.B. Keeler of the *Atlanta Journal*:

"You see, every year when I was planning our poster campaign, I had artist chaps in conference to design the posters—circus posters...they made sketches...it seemed to me every now and then that they missed something in the action of the galloping horses—something that missed the grace and spirit of a lion at bay, the Hogarthian line of beauty in the pose of a feminine gymnast."

His interest was further stimulated by

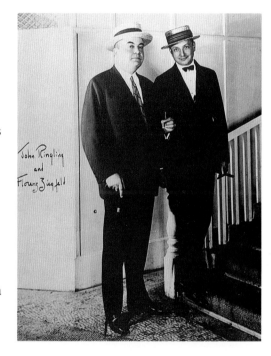

THIS PAGE: John Ringling with Flo Ziegfeld (date unknown). FAR RIGHT: Mable Ringling, c. 1910.

professionals like the architect Stanford White, who was one of his first New York friends. John Ringling loved the excitement and sophistication of city life and the company of celebrities, from prize fighters to politicians. While his brothers returned each winter to Baraboo, John early on took an apartment in Chicago and by the turn of the century was a familiar figure in New York where he soon established his residence. He maintained a beautiful apartment at 636 Fifth Avenue for many years until the building was demolished to make way for Rockefeller Center. In 1919, he bought a large estate in Alpine, New Jersey—just across the Hudson River from Yonkers—for a summer residence.

John's responsibilities with the circus did not involve him in its day-to-day operations, and after the first successful years, he began to expand and diversify his business interests. His major enterprises included railroads and oil wells, but he also invested in real estate and owned small businesses in many parts of the country. He frequented fine hotels and clubs and was easily recog-

nized— an elegant figure, six feet four inches tall, soft-spoken, impeccably groomed, and perfectly dressed.

In 1905, John married Mable Burton, then 30 years old, who had grown up on her family's farm at Moons, Ohio. She was an exceptionally beautiful woman—tall, with masses of dark brown hair and lovely brown eyes—and she was always the love of his life. Mable had a quiet manner and an innate sense of perspective. She also had a grand sense of humor and was a good companion, sharing many of her husband's interests, including art.

Although the Ringlings made annual visits to Sarasota after buying the Thompson house in 1912, it was a number of years before they took any part in the community. Their social life was restricted to old friends (like their neighbors, Ralph and Ellen Caples), and other members of the family. Charles Ringling and his wife Edith bought property adjoining John's, and Alfred and Al and their families also were winter visitors.

(The Charles Ringling property is now the campus of New College of the University of South Florida; the marble mansion built by Charles in 1926 is known as College Hall, and the adjoining house, built for his daughter Hester, has been named Cook Hall.)

All of the Ringling brothers had fine yachts, which they sent down to Florida and sailed on Sarasota Bay, and in 1917, John bought the Cedar Point property (now Golden Gate Point) where the Yacht and Automobile Clubs were located. The next year, he established a real estate development organization called John Ringling Estates, and the Ringling Bros. and Barnum & Bailey circus advertised Florida's West Coast as it toured the nation.

For the next decade, John Ringling was a vital force in the development of Sarasota. He built—and gave to the city —the causeways linking the mainland to the barrier islands (which he owned) and over New Pass to Longboat Key, where he began a magnificent resort hotel, the Ritz-Carlton, later a victim of the 1920s land bust. He was active in the Chamber of Commerce, serving as president, and he bought vast acreage. St. Armands Key was one of his favorite projects: he laid it out himself, with an area planned for fine shops rimmed by residential development. He brought down John Watson, a top notch New York landscape architect, to do the circle. "Now Mable won't have to go to Palm Beach to shop," he said.

When the Florida land boom went sour, John decided to give the local economy a boost by transferring the circus winter quarters from Bridgeport, Connecticut, to Sarasota. The move was made at the end of the 1927 season, and after that, winter visitors were delighted to pay 25 cents to watch the circus in rehearsal for the coming tour; the money went to the Salvation Army to provide assistance for Sarasota's needy.

In 1926, John and Mable celebrated Christmas in the newly-completed Ca' d'Zan, and in 1927, construction began on the art museum. Although Mable saw the building finished before her untimely death from Addison's disease in June of 1929, she did not live long enough to see the paintings installed.

It was Mable's nature to keep a certain reserve about her and she did not make intimate friends; intimacy was confined to the family circle. But she had given much to Sarasota in her support of the Garden Club (she was the founding president), her fostering of art in the community, and her philanthropic contributions, which included opening her home to large groups for parties. She was greatly respected and sincerely mourned.

"Not only did everyone like her, but she was a real force," said John Phillips, architect for the Museum, who admired her enormously.

The loss of Mable was the first of the tragedies that beset John Ringling at the end of his life. His financial affairs became increasingly tangled, a brief second marriage was most unhappy, his health failed him, and ultimately, he lost control of the circus. His business difficulties were later understood to be problems of cash flow, (he was still a multi-millionaire when he died on

THIS PAGE: (left) Lower Main Street, Sarasota, 1926; (right) John Ringling's yacht, Zalophus. *FAR RIGHT: John Ringling's barber chair in Siena marble bathroom.*

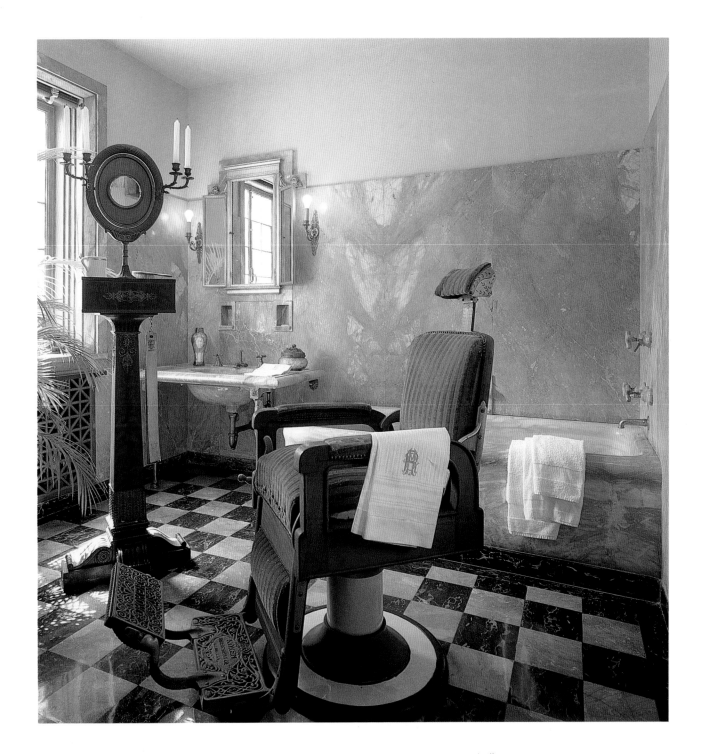

December 2, 1936), but he could not make use of his resources and his last years were troubled and sad.

In 1930, with the Museum building finished and paintings hanging in the galleries, a special preview showing was planned for the community at the end of March. On the 18th of that month, Sarasota's business leaders held a dinner, honoring John Ringling for: "...The crowning feature of his great triumph, The John and Mable Ringling Museum of Art, which would go far toward making Sarasota - and assuring its destiny as

- an art center of greatest magnitude."

John Ringling seldom spoke in public—it made him uneasy and his face would grow red, but on this occasion he offered a few remarks:

"Any little thing that I have done from time to time," he said, "I have been most happy to do. Because this is my home town and I love Sarasota better than any other place on earth. I very much appreciate the honor...and I thank you from the bottom of my heart."

VISITOR INFORMATION

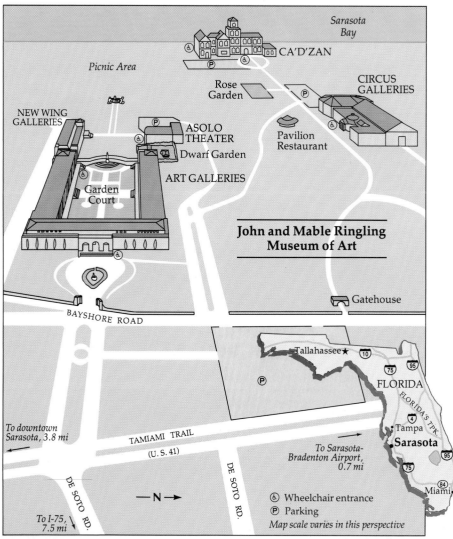

Sarasota Bay

CA'D'ZAN

Picnic Area

Rose Garden

CIRCUS GALLERIES

NEW WING GALLERIES

ASOLO THEATER

Dwarf Garden

Pavilion Restaurant

ART GALLERIES

Garden Court

John and Mable Ringling Museum of Art

Gatehouse

BAYSHORE ROAD

Tallahassee ★

FLORIDA

To downtown Sarasota, 3.8 mi

TAMIAMI TRAIL

(U.S. 41)

Tampa

Sarasota

To Sarasota-Bradenton Airport, 0.7 mi

Miami

DE SOTO RD.

DE SOTO RD.

← N →

To I-75, 7.5 mi

Wheelchair entrance

Parking

Map scale varies in this perspective